Beaded Felt
Jewellery

Helen Birmingham

Search Press

First published in Great Britain 2008

Search Press Limited
Wellwood, North Farm Road,
Tunbridge Wells, Kent TN2 3DR

Text copyright © Helen Birmingham 2008

Photographs by Roddy Paine Photographic Studio

Photographs and design copyright
© Search Press Ltd 2008

ISBN-13: 978-1-84448-315-0

Suppliers
If you have difficulty in obtaining any of the
materials and equipment mentioned in this book,
then please visit the Search Press website for
details of suppliers: www.searchpress.com

Dedication
For my dear friend, Kathy

Contents

Introduction

In this book I will show you how you can use the humble felt square to create sophisticated and fashionable felt jewellery without the need for specialist materials or wet, soapy hands!

All the designs are based around eight simple methods for binding and decorating felt beads, and these are shown on pages 6–7. As you will see, the overall effect of these beads is stunning, yet the technique to make them could not be easier!

I use bright colours and bold designs for maximum impact – be inspired by them, and adapt them to suit your own personal taste or style.

A friend once told me that my jewellery was as exciting as a sweet shop – but without the calories! I hope you will find this collection of necklaces, bracelets and earrings equally as delicious, and that it will whet your appetite for creating gorgeous designs of your own.

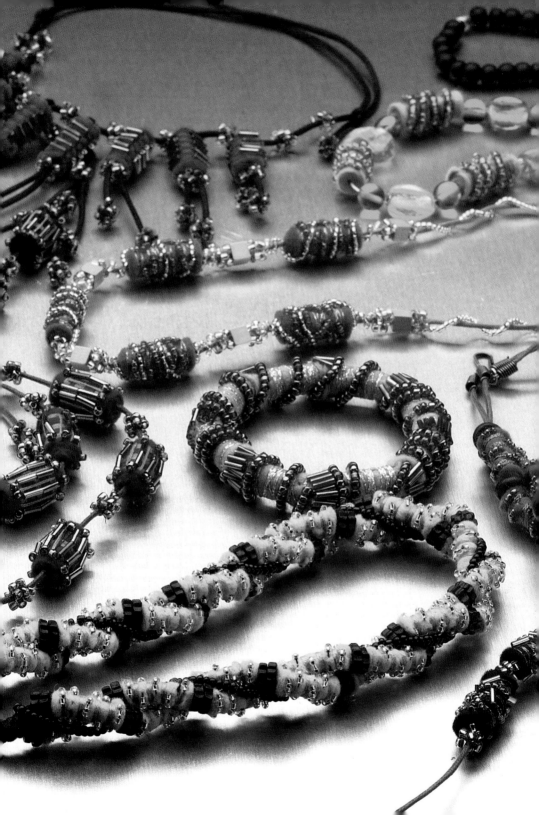

Methods

All the beads I have used are based around the principle of rolling a piece of felt tightly around a stick and binding it with thread to form a bead. I find that bamboo sticks are ideal as they are very smooth and uniform in size, but wooden skewers, cocktail sticks or even thin knitting needles work just as well. Avoid using drinking straws, because you may stitch through the straw when adding decoration and then be unable to remove the bead! Hold the roll in place while you bind and decorate the bead by either simply holding it, or adding a small amount of fabric glue.

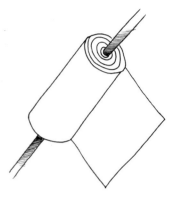

Basic rolling technique

As with all handmade beads, slight irregularities in size and shape are welcomed and it is not vital that the felt pieces are cut to exact measurements, but I would recommend that all the felt pieces for one project are cut at the same time. Keep the finished beads on the stick until you are ready to use them – without the stick they flatten easily and you can end up losing the hole!

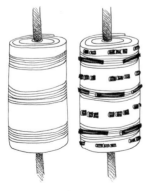

Method A

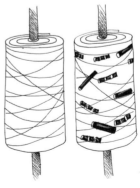

Method B

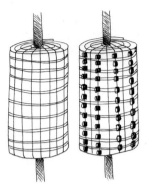

Method C

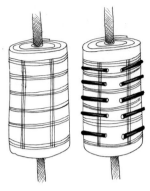

Method D

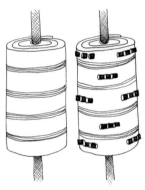

Method E

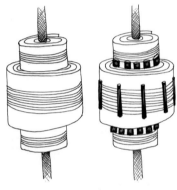

Method F

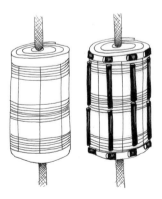

Method G

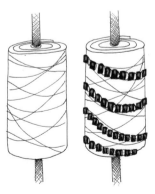

Method H

Sweet Peanut Bracelet

Materials:

6 x tan felt pieces, 2.5 x 6cm
 (1 x 2¼in)

6 x yellow wooden
 spacer beads

Selection of gold/yellow
 seed beads

Selection of gold/yellow
 bugle beads

Tan embroidery thread

Beading thread

Round elastic

Tools:

Scissors

Beading needle

Needle

Instructions:

1 Bind the felt pieces into six beads using embroidery thread and attach seed beads and bugle beads, following method A.

2 Thread felt beads and spacer beads alternately on to the elastic.

3 Tie a knot securely in the elastic, keeping the elastic taut but not fully stretched.

4 Cut off the ends of the elastic close to the knot.

5 Gently pull the elastic through one of the felt beads, so that the knot sits invisibly within the bead.

Turkish Delight

Use passionate pinks and purples to create a bracelet hot enough to sizzle on a night full of Eastern Promise.

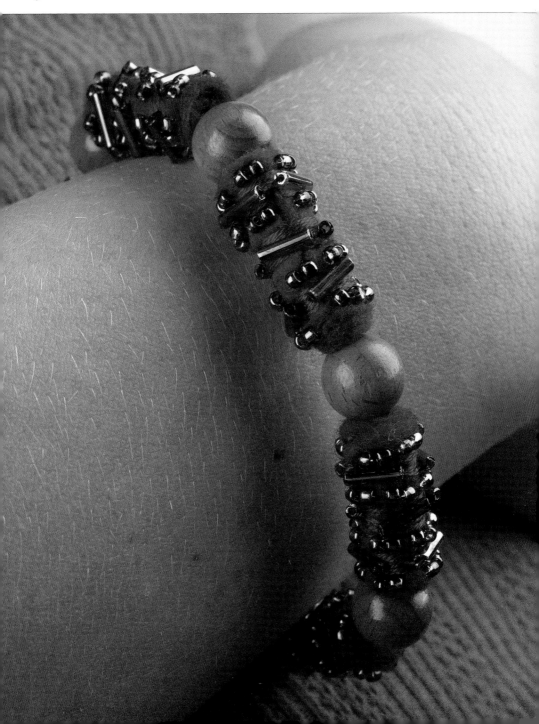

Strawberry Bonbons

Materials:

5 x bright pink felt pieces, 2.5 x 6cm (1 x 2¼in)

6 x pink wooden spacer beads

8 x white wooden spacer beads

Selection of pink seed beads

Sparkly pink embroidery thread

Medium cotton cord

Beading thread

2 x round leather crimps

1 x sprung hook

Tools:

Scissors

Flat-nose pliers

Beading needle

Needle

Instructions:

1 Bind the felt pieces into five beads using sparkly thread and attach the seed beads, following method B.

2 Thread five spacer beads on to the cord, then alternate felt and spacer beads, finishing with the last five spacer beads.

3 Knot the cord securely at each end of the beading. This prevents the fastening from moving round to the front when you are wearing the necklace.

4 Cut the ends of the cord to the desired length.

5 Attach a leather crimp to each cut end of the cord.

6 Attach the hook to one of the crimps.

Toffee Popcorn

Changing the colour scheme to soft beiges and browns gives this design a more natural, subdued look.

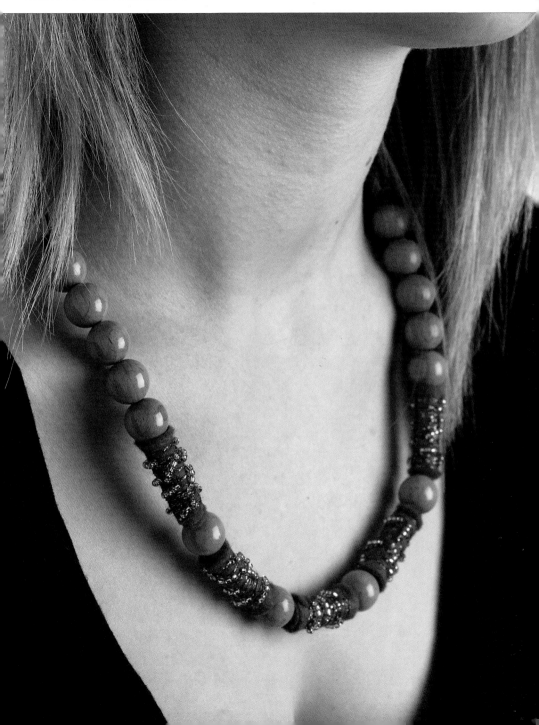

Cola Drops

Materials:

2 x orange-coloured felt pieces, 2.5 x 6cm (1 x 2¼in)
4 x flat black spacer beads
4 x small gold beads
2 x headpins
2 x long ball wire earring hooks
Selection of gold/yellow seed beads
Selection of gold/yellow bugle beads
Tan embroidery thread
Beading thread

Tools:

Round-nose pliers
Flat-nose pliers
Cutting pliers
Scissors
Beading needle
Needle

Instructions:

1 Bind the felt pieces into two beads using embroidery thread
 and attach seed beads and bugle beads, following
 method A.

2 Thread beads on to a headpin in the following
 order – small gold bead, flat black spacer,
 felt bead, flat black spacer and small
 gold bead.

3 Snip the headpin to length, and create
 a loop. You need to leave about 1cm
 (½in) of headpin above the beading
 to form the loop.

4 Attach an earring hook to the loop.

5 Repeat for the second earring.

Raspberry Drops

This colour scheme matches the Turkish Delight bangle on page 9. Making matching earrings is a simple and subtle way of adding coordination to your outfit.

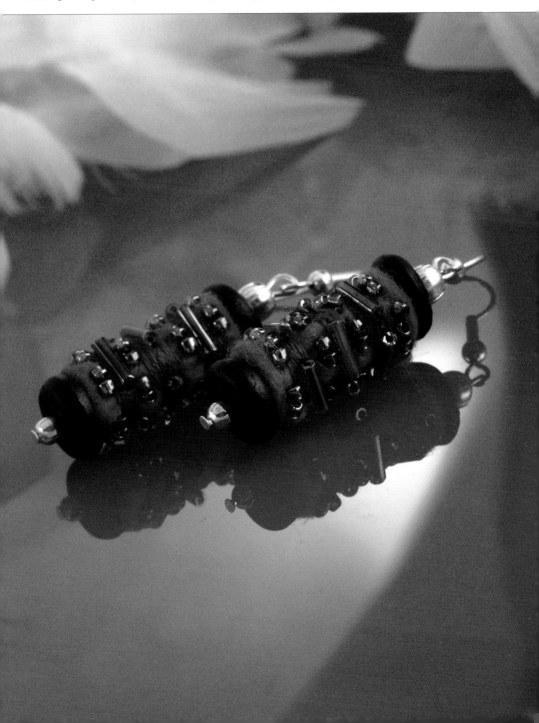

Liquorice Whip

Materials:
15 x black felt pieces, 2.5 x 6cm (1 x 2¼in)
Selection of black seed beads
Selection of black bugle beads
Black embroidery thread
Beading thread
Medium cotton cord
2 x round leather crimps
1 x sprung hook

Tools:
Scissors
Flat-nose pliers
Beading needle
Needle

Instructions:

1 Bind the felt pieces into fifteen beads using embroidery thread and attach seed beads and bugle beads, following method A.

2 Thread the felt beads on to the cord.

3 Knot the cord securely at each end of the beading. This prevents the fastening from moving round to the front when you are wearing the necklace.

4 Add more knots for decoration.

5 Cut the ends of the cord to the desired length.

6 Attach a leather crimp to each cut end of the cord.

7 Attach the hook to one of the crimps.

Rhubarb and Custard

For a complete change from the dark sophistication of the black necklace, try using a combination of pinks and yellows to make a lighter, more summery necklace.

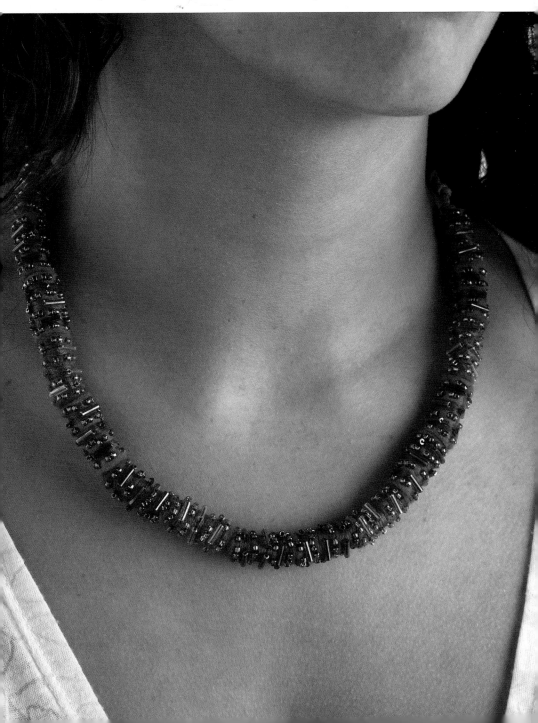

Blackberry Sundae

Materials:

5 x bright pink felt pieces, 2.5 x 6cm (1 x 2¼in)
Selection of pink seed beads
Selection of dark purple seed beads
Selection of dark purple bugle beads
Sparkly pink embroidery thread
Medium cotton cord
Beading thread

Tools:

Scissors
Beading needle
Needle

Instructions:

1 Bind the felt pieces into five beads using sparkly thread and attach seed beads, following method B.

2 Stitch a few dark purple bugle beads randomly on to the felt beads.

3 Thread one felt bead on to the cord and position it at the centre of the cord.

4 Stitch seed beads directly on to the cord, forming clusters at each end of the felt bead. Use ten seed beads for each cluster.

5 Repeat by threading felt beads and creating clusters, making sure that you keep the felt beads pushed up tightly against the clusters.

6 Tie a sliding knot on to the cord, and decorate the cut ends with seed bead clusters.

Blackcurrant and Liquorice

One of my favourite colour combinations is lilac and blue. Here I have used it to excellent effect by contrasting it against the deep black felt. The result is vivid but sophisticated.

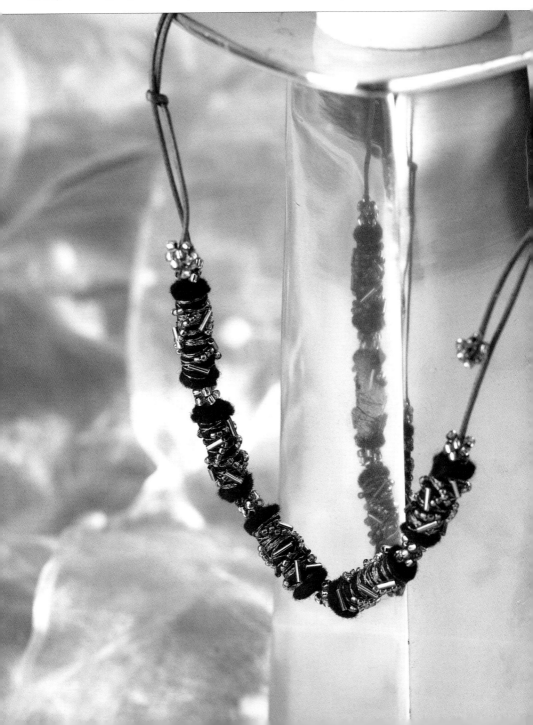

Mango Cluster

Materials:

8 x red felt pieces, 2.5 x 8cm
(1 x 3¼in)

Selection of iridescent bronze
seed beads

Selection of iridescent bronze
bugle beads

Soft orange
embroidery thread

2 x lengths of medium
cotton cord

Beading thread

Tools:

Scissors

Beading needle

Needle

Instructions:

1 Bind the felt pieces
into eight beads using
embroidery thread and
attach seed beads,
following method G.

2 Thread one felt bead on
to the first cord and position it at
the centre of the cord.

3 Secure this bead in place by stab
stitching directly into the cord using beading thread.

4 Stitch seed beads directly on to the cord to form clusters. Use ten seed beads
for each cluster and leave a gap of about 1cm (½in) between each cluster and
felt bead.

5 Repeat by threading felt beads and creating clusters until you have five beads
and six clusters stitched into place on the cord.

6 Tie a sliding knot on to the cord, and decorate the cut ends with seed
bead clusters.

7 Thread the remaining three felt beads on to the second length of cord and
stitch them into place, leaving 1cm (½in) gaps between beads.

8 Create seed bead clusters about 1cm (½in) from the felt beads.

9 Knot the second cord into place, just above the top cluster of beads on the
first cord.

10 Decorate the knot and cut ends of cord with clusters of seed beads to finish.

Black Jack Bonanza

Change the colour scheme to black and purple, and worn with your 'little black dress' this necklace would send shivers down any pirate's spine!

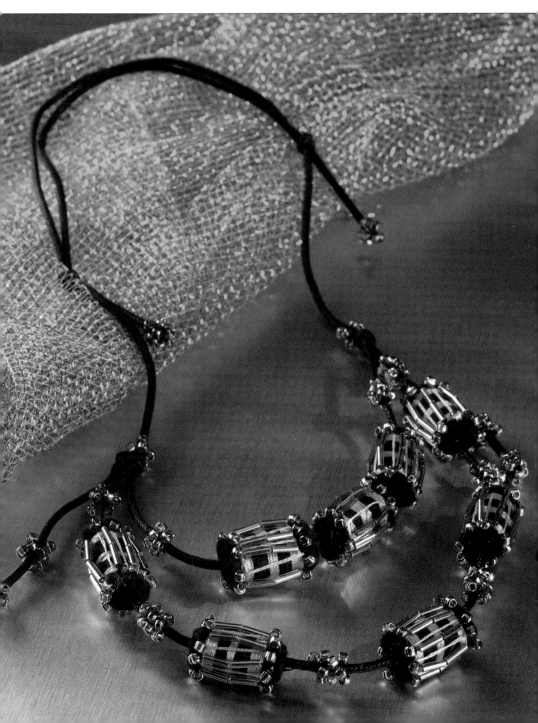

Pink Candy String

Materials:

5 x pink felt pieces, 2.5 x 6cm (1 x 2¼in)

Selection of pink seed beads

Selection of lime green seed beads

8 small square wooden beads

Sparkly pink embroidery thread

Medium cotton cord

Beading thread

2 x round leather crimp

1 x sprung hook

Tools:

Scissors

Beading needle

Needle

Flat-nose pliers

Instructions:

1 Bind the felt pieces into five beads using embroidery thread and attach seed beads, following method B.

2 Thread one felt bead on to the cord and position it centrally.

3 Secure the bead in place by stab stitching directly into the cord using beading thread.

4 Stitch ten seed beads directly on to the cord to form a cluster, approximately 1cm (½in) from the felt bead.

5 Thread a square bead on to the cord and push it firmly against the cluster. Stitch a second cluster of beads close up to the end of the square bead.

6 Repeat steps 2–5 until you have five beads and six clusters stitched into place on the cord.

7 Thread a square bead on to each end of the cord and temporarily leave it loose.

8 Cut the cord to length and attach a leather crimp to each end.

9 Attach a hook to one leather crimp to finish the fastening.

10 Making sure the loose wooden beads are pushed up next to the fastenings, anchor a length of beading thread directly on to the cord about 6cm (2¼in) from one of the fastenings.

11 Add a string of seed beads, wrapping the string around the necklace and anchoring it in place every now and then, finishing about 6cm (2¼in) from the other fastening.

12 Push the loose wooden beads down to cover the ends of the seed bead strings.

Orange and Lemon Candy String

Use bright orange and yellow for a zesty string of sunshine. Perfect for those long, hot summer days.

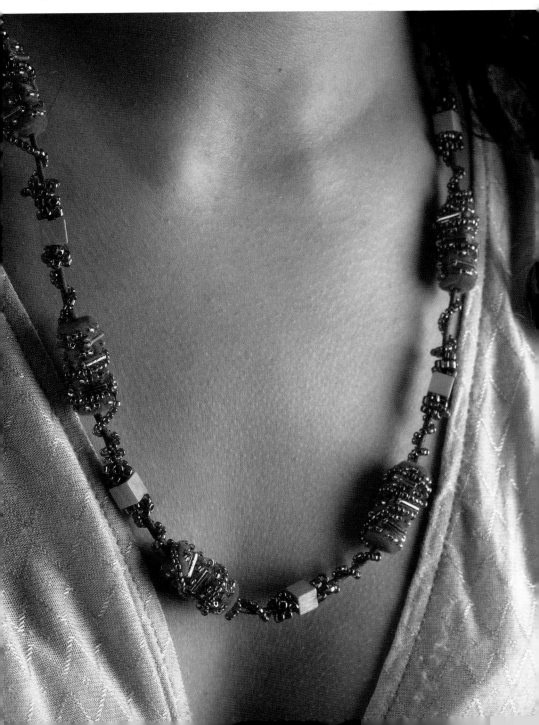

Juicy Blackberry Glasses

Materials:

4 x purple felt pieces, 2.5 x 3cm (1 x 1¼in)
4 x black felt pieces, 1 x 9cm (½ x 3½in)
Selection of iridescent purple seed beads
Selection of iridescent purple bugle beads
Mauve embroidery thread
Medium cotton cord
Beading thread
2 x spectacle ends

Tools:

Scissors
Beading needle
Needle

Instructions:

1 Bind the felt pieces into four beads using embroidery thread and attach seed beads, following method F.

2 About 20cm (7¾in) from one end of the cord, stitch ten seed beads directly on to the cord to form a cluster.

3 Thread one felt bead on to the cord and position it about 2cm (¾in) away from the cluster.

4 Secure this bead by stab stitching directly into the cord using beading thread.

5 Stitch a second cluster and attach a second felt bead in the same way, again leaving about 2cm (¾in) between each.

6 Thread the cord through a spectacle end and double back on itself, securing the loop with another seed bead cluster.

7 Make sure the cord is cut to a comfortable length for the wearer. Repeat this beading pattern at the other end of the cord.

Bubble Gum

Although spectacle cords may have a reputation for being a little old-fashioned, nothing could be further from the truth with this bubbly, bright pink and blue colour scheme.

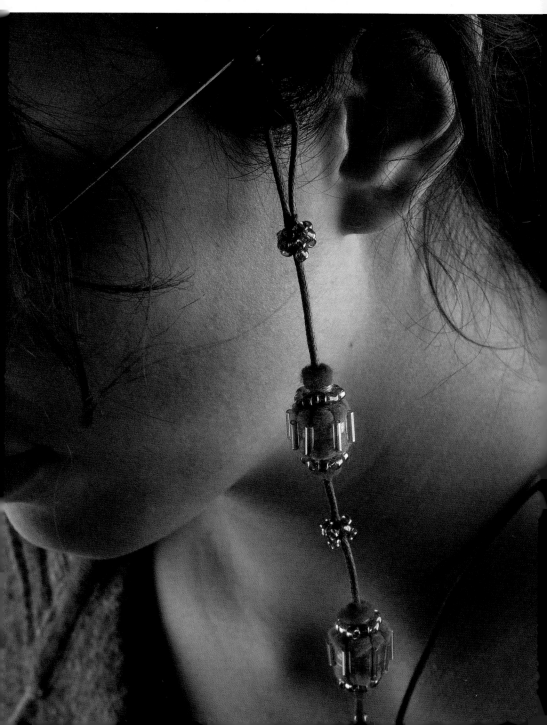

Prickly Pear Drops

Materials:

7 x black felt
 pieces, 2.5 x
 8cm (1 x 3¼in)
Selection of iridescent
 green seed beads
Selection of iridescent
 green bugle beads
Green embroidery
 thread
Medium cotton cord
Beading thread

Tools:

Scissors
Beading needle
Needle

Instructions:

1 Bind the felt pieces into seven beads using embroidery thread and attach seed beads and bugle beads, following method D.

2 Cut seven lengths of cord, each about 14cm (5½in) long.

3 Fold one piece of cord in half, and pass the folded end through a felt bead. You will then have a loop at one end of the bead and the two cut ends of cord at the other.

4 Repeat for the other six felt beads.

5 Thread the loops on to cotton cord and space them out evenly, leaving gaps of about 3cm (1¼in) between each bead.

6 Secure these beads into place by stab stitching directly into the cord using beading thread. Make sure the beads are pushed firmly up to the cord at the top.

7 Stitch seed beads directly on to the cord to form a cluster at the base of each felt bead. Use ten seed beads for each cluster. Make sure the thread passes securely through both cords.

8 Stitch a cluster of seed beads on to each cut end of the cord.

9 Stitch a cluster of seed beads between each felt bead, again stitching directly into the cord.

10 Tie a sliding knot, and decorate the cut ends with further clusters of seed beads.

Tiger Lily

You will certainly get yourself noticed in this exotic and hot creation. Simply change the colours to reds and oranges but keep the vivid impact of the black cord. Sensational!

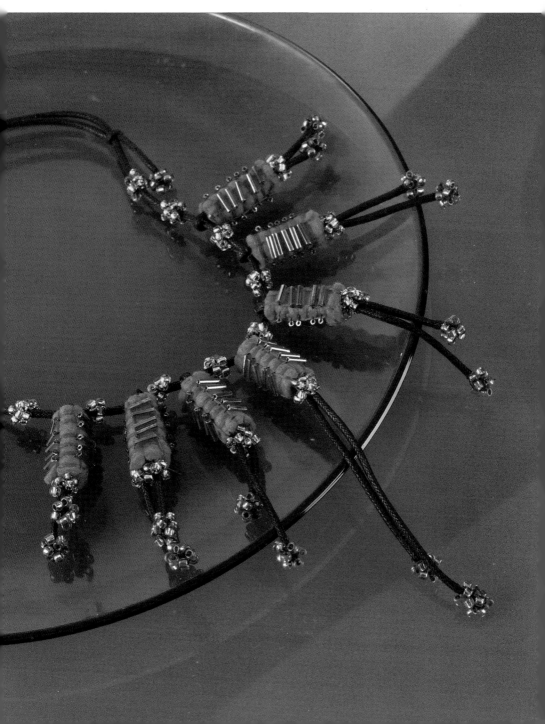

Rainbow Drops Wristband

Materials:

15 x black felt pieces, 3 x 8cm (1¼ x 3¼in)
Selection of mixed rainbow seed beads
Black embroidery thread
Beading thread
1m (39½in) length of round elastic

Tools:

Scissors
Beading needle
Needle

Instructions:

1 Bind the felt pieces into fifteen beads using embroidery thread and attach seed beads, following method C.

2 Thread one felt bead on to the elastic and move the bead to the centre.

3 Take the next felt bead and pass one end of the elastic through it from left to right. The other end of the elastic goes through the same bead, but from right to left.

4 Pull it gently into place alongside the first bead.

5 Repeat with all fifteen beads.

6 Finally, pass one end of the elastic back through the first bead, and tie the ends securely.

7 Gently pull the elastic round until the knot is hidden inside a felt bead.

Orange Drops

Changing the colour scheme to oranges and pinks gives a light and frivolous look to this easy-to-wear wristband.

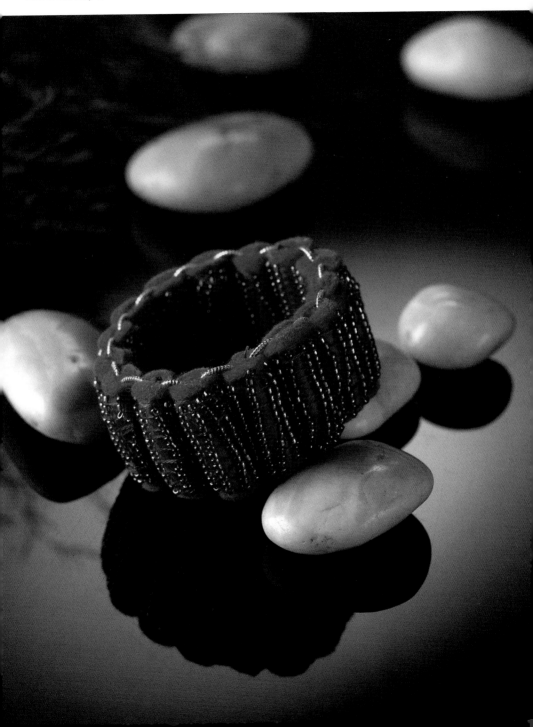

Twisted Liquorice Delight

Materials:

32 x bright pink felt pieces,
 2.5 x 4cm (1 x 1½in)

Selection of pink seed beads

Selection of blue seed beads

34 x flat black spacer beads

Electric blue
 embroidery thread

Beading thread

2 x lengths medium
 cotton cord

4 x round leather crimps

2 x jump rings

1 x sprung hook

Tools:

Scissors

Flat-nose pliers

Beading needle

Needle

Instructions:

1 Bind the felt pieces into thirty-two beads using embroidery thread and attach seed beads, following method E.

2 Thread seventeen spacer beads and sixteen felt beads on to the first cord.

3 Repeat for the second cord.

4 Tie a knot at one end of the beads on each cord, and tie the two cords together at the other end. From here onwards, treat the cords as one length (with the knot in the middle).

5 Holding one end firmly, twist the cords over and over until you can feel tension in the twist.

6 Still holding both ends tightly, take hold of the knot in the middle and allow the whole cord to twist back on itself. Trust it – it will find its own shape.

7 If the necklace is not twisted enough, stretch the two ends open again and twist some more.

8 When you are happy with the amount of twist, knot the two open ends of cord together securely to hold the twist in place.

9 Cut all four ends of cord to length evenly and attach leather crimps to each end.

10 Attach jump rings to the crimps and attach a hook to one ring to complete the fastening.

11 Thread a length of seed beads on to beading thread and intertwine it through the necklace, anchoring it every now and then with stab stitches worked directly through the felt beads.

Twist of Lime

The contrast of the bright lime green against black is stunning. Try this colour combination to create a piece of jewellery with real impact.

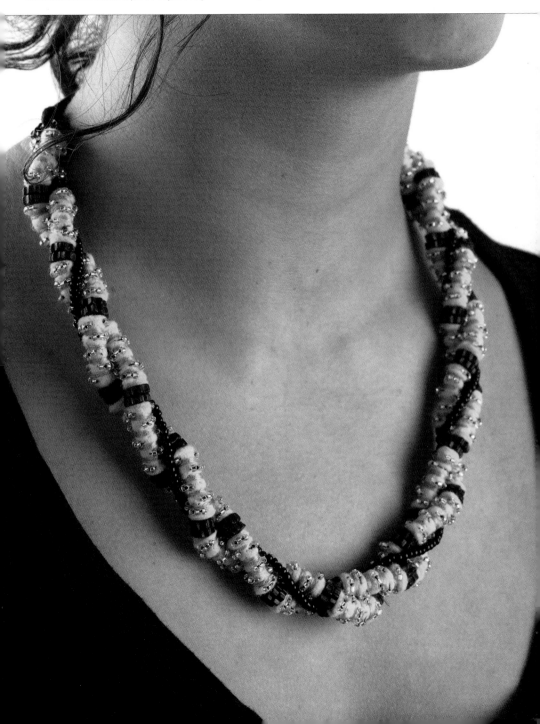

Coconut Ice Necklace

Materials:

12 x pale pink felt pieces, 2.5 x 8cm
(1 x 3¼in)

Selection of silver/clear seed beads

Selection of silver bugle beads

Pink sparkly embroidery thread

Beading thread

Medium cotton cord

2 x round leather crimps

1 x sprung hook

Tools:

Scissors

Flat-nose pliers

Beading needle

Needle

Instructions:

1 Bind the felt pieces into twelve beads using embroidery thread, following method B.

2 Thread the felt beads on to the cord.

3 Make sure the beads are pushed together tightly and knot the cord securely at each end of the beading.

4 Using embroidery thread, darn the ends of the felt beads together using stab stitches.

5 Stitch bugle beads over the join to decorate.

6 Add strings of seed beads, twisting and turning them around the felt beads and anchoring every now and then by stab stitching directly through the cord.

7 Cut the cord to length and attach a leather crimp to each cut end of the cord.

8 Attach a hook to one of the crimps to finish.

Ice Cool Blue

I love the simplicity of this necklace when completed in different shades of blue. It would suit all occasions, formal or informal.

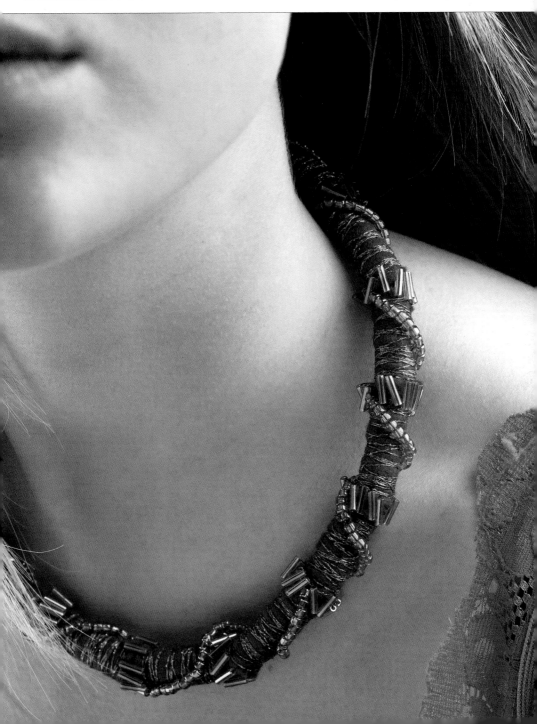

Peppermint Moss Bangle

Materials:
8 x green felt pieces, 2.5 x 8cm (1 x 3¼in)
Selection of iridescent green seed beads
Selection of iridescent green bugle beads
Copper-coloured sparkly embroidery thread
Beading thread
Medium cotton cord

Tools:
Scissors
Beading needle
Needle

Instructions:

1 Bind the felt pieces into eight beads using embroidery thread, following method B.

2 Thread the felt beads on to the cord and knot the cord securely to form a bangle. This will make a fixed-size bangle, so ensure the size is correct before continuing. If the bangle needs to be larger, add a ninth felt bead.

3 Carefully position the knot inside one of the felt beads.

4 Using embroidery thread, darn the ends of the felt beads together using stab stitches. (Be aware that you will need to lengthen the stitches to accommodate the outside curve of the bangle.)

5 Stitch bugle beads over the join to decorate.

6 Add a string of seed beads, twisting and turning it around the felt beads and anchoring it every now and then by stab stitching directly through the cord.

Forget-me-not

This bangle would make a perfect gift for a sister or mother. Cool blue teamed with silver is a timeless combination.

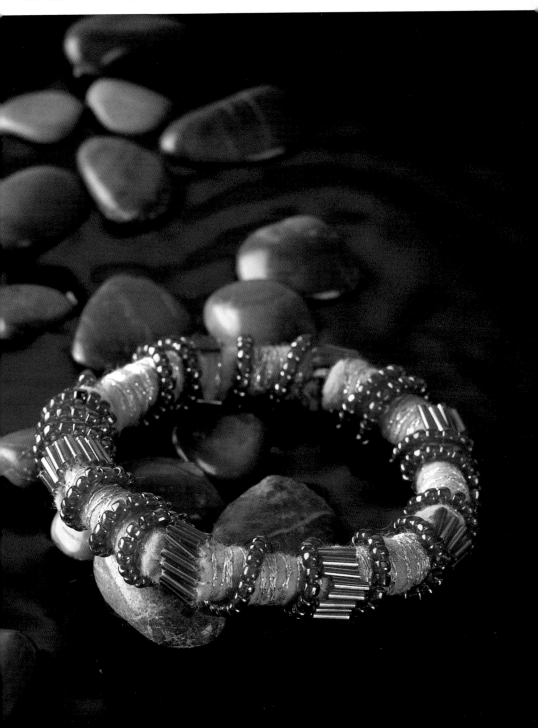

Parma Violet Headband

Materials:

5 x white felt pieces, 8 x 11cm (3¼ x 4¼in)
Selection of silver/clear seed beads
Selection of pale purple seed beads
Selection of pale purple bugle beads
Silver sparkly embroidery thread
Beading thread
Medium cotton cord
Round elastic

Tools:

Scissors
Beading needle
Needle

Instructions:

1 Bind the felt pieces into five long beads using embroidery thread and attach seed beads and bugle beads, following method E.

2 Thread the felt beads on to the cord.

3 Keeping the beads in a straight line, use embroidery thread to darn the ends of the felt beads together using stab stitches.

4 Stitch bugle beads over the join to decorate.

5 Tie one end of the cord to the elastic and pull the knot up at least 4cm (1½in) inside the felt bead.

6 Trim the other end of the cord so that about 4cm (1½in) is protruding from the bead. Cut the elastic to length, making sure the overall length of the headband is correct, and tie the elastic on to the loose end of the cord.

7 Reposition the cord and elastic, so that both knots are hidden inside beads.

8 Bind the open ends of the felt beads with blanket stitch.

9 Add strings of seed beads, twisting and turning them around the felt beads and anchoring every now and then by stitching directly through the cord.

Aniseed Twist

This headband makes the perfect adornment for a bridesmaid. Match the colour to your wedding, and she will have not only a unique and beautiful piece of jewellery but also a treasured keepsake.

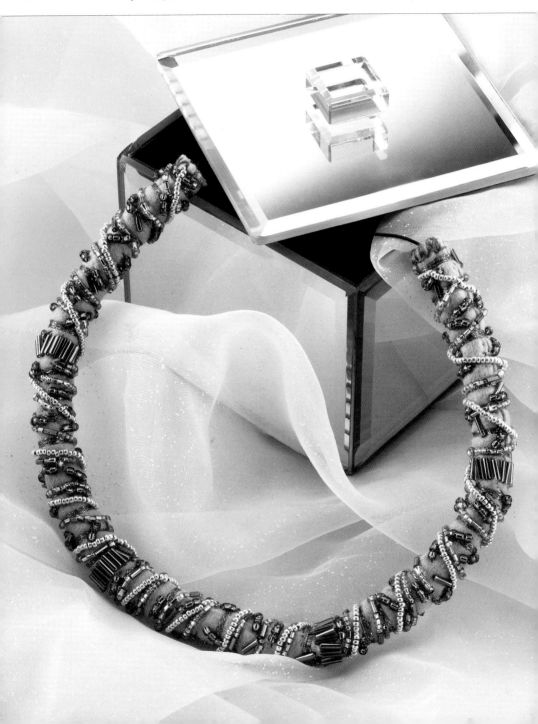

Barley Sugar Hairslides

Materials:

2 x rust-coloured felt pieces, 8 x 11cm (3¼ x 4¼in)
Selection of black seed beads
Rust-coloured embroidery thread
Copper-coloured sparkly embroidery thread
Beading thread
2 x 6cm hairslides

Tools:

Scissors
Beading needle
Needle

Instructions:

1 Bind the felt pieces into long beads using embroidery thread, following method E.

2 Bind the open ends of the beads with blanket stitch and decorate them with sparkly thread.

3 Attach seed beads to the top surface of each felt bead, making sure that the back of each bead remains free of decoration.

4 Stitch each felt bead securely on to a hairslide, using the holes provided in the back of each slide.

Coffee and Cream

You could use these hairslides to complement the bridesmaid's headband shown on the previous page. Simply match the colour to the wedding or chosen outfit.

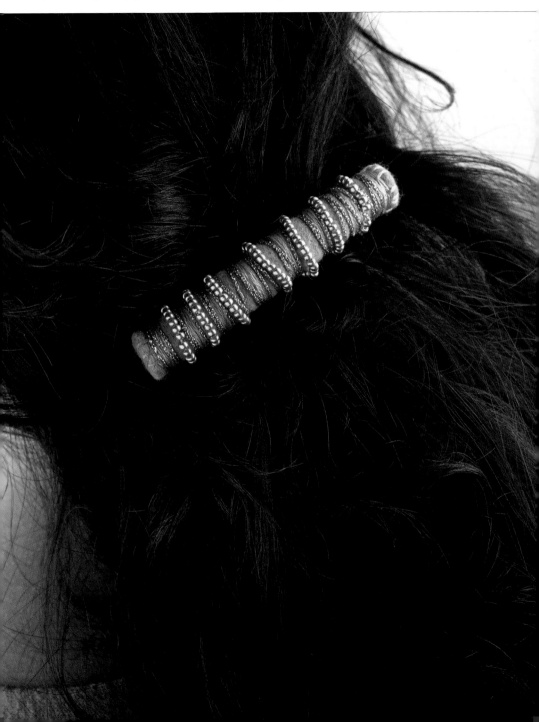

Fruit Spangle Bangle

Materials:

5 x felt pieces in a variety of colours and sizes
20 x small red glass spacer beads
Selection of red seed beads
Pink embroidery thread
Beading thread
Round elastic

Tools:

Scissors
Beading needle
Needle

Instructions:

1 Bind the felt pieces into five beads using embroidery thread
 and attach seed beads, following a variety of methods.
2 Thread felt beads and spacer beads on to the elastic.
3 Tie a knot securely in the elastic, keeping the elastic taut but
 not fully stretched.
4 Cut the ends of the elastic close to the knot.
5 Gently pull the elastic through one of the felt beads so that
 the knot sits invisibly within the bead.

Liquorice Allsorts

These colours are so evocative! The only problem is, wearing this bangle makes me feel hungry!

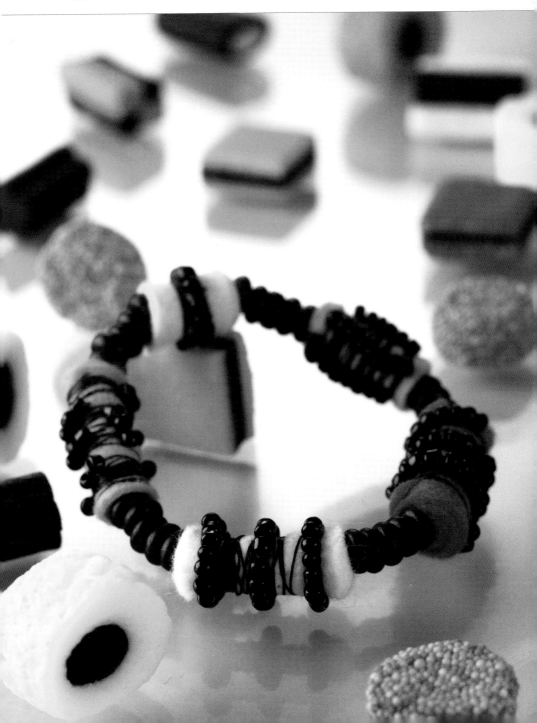

Hazelnut Whirl Necklace

Materials:

3 x brown felt pieces, 2.5 x 6cm (1 x 2¼in)
42 x black spacer beads
4 x decorative glass beads
Selection of brown seed beads
Brown embroidery thread
Beading thread
Magnetic clasp

Tools:

Scissors
Beading needle
Needle

Instructions:

1 Bind the felt pieces into three beads using embroidery thread and attach seed beads, following method H.

2 Knot beading thread on to the magnetic clasp and thread seventeen spacer beads on to the thread.

3 Continue threading a combination of glass beads, spacer beads and felt beads to your chosen design. (Your design will depend on the exact beads you have sourced.)

4 Finish by threading the remaining seventeen spacer beads on to the thread.

5 Pass the thread back through the magnetic clasp and rethread it right the way round the necklace (so doubling its strength). Tie the ends securely and hide the knots inside the beads.

Ice Cube Whirl

Transform this necklace from warm, nutty brown into cool, crisp elegance simply by changing the colour to ice cool blues. Irregular-shaped glass beads complement the structure of the seed bead spirals.

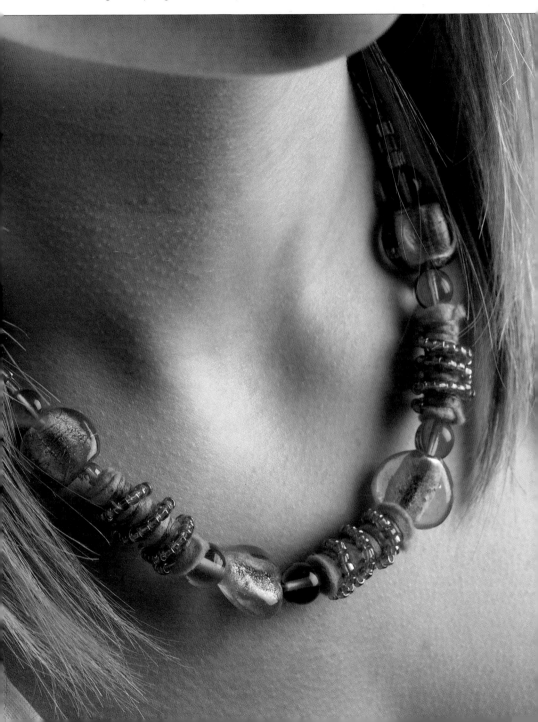

Pink Sugar Doughnut

Materials:

2 x pink felt pieces, 2 x 3cm (¾ x 1¼in)
Selection of silver seed beads
Sparkly pink embroidery thread
Beading thread
Medium cotton cord
Large aluminium doughnut

Tools:

Scissors
Beading needle
Needle

Instructions:

1 Bind the felt pieces into two beads using sparkly thread, following method B.

2 Thread the felt beads on to the cord.

3 Knot the cord on to the doughnut, positioning the felt beads so that they lie on the front surface.

4 Stitch seed beads on to the front surface of the felt beads.

5 Tie a sliding knot on to the cord and decorate the cut ends with seed bead clusters to finish, stitching the beads directly on to the cord.

Blueberry Doughnut

This design is simple, but is also a very effective way of adding extra interest to any shop-bought pendant. The change in colour can make a dramatic difference to the look of your main piece.

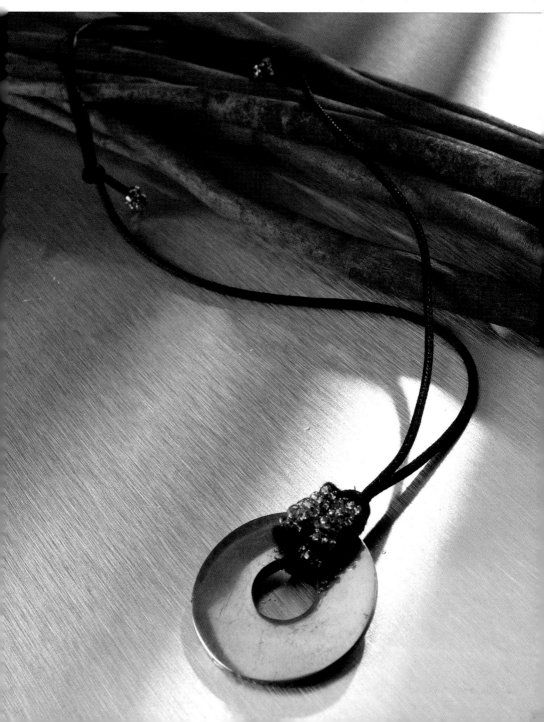

Fizzy Cherry Jellyfish

Materials:

1 x red felt piece, 3 x 6cm
 (1¼ x 2¼in)
Selection of pink seed beads
Selection of small silver beads
2 x red glass spacer beads
4 x medium silver beads
Pink embroidery thread
Beading thread
2 x silver calottes
1 x silver headpin
1 x silver bolt ring and eye

Tools:

Scissors
Flat-nose pliers
Round-nose pliers
Beading needle
Needle

Instructions:

1 Bind the felt piece into a bead using embroidery thread
and attach seed beads, following method H.

2 Using beading thread and seed beads, create a tassel-like
frond from the felt bead – thread the desired number of
seed beads on to the thread, then thread on a small silver
bead. Pass the needle back up through the seed beads
(missing out the silver bead!) and anchor securely
into the felt bead.

3 Repeat step 2 to create more fronds.

4 Thread one medium silver bead, the felt bead and a
second medium silver bead on to the headpin.

5 Form a loop in the end of the headpin.

6 Using beading thread, make a string of seed beads, adding the medium silver
beads, the glass spacer beads and the felt bead to the centre of the string.

7 Pass the thread back through all the beads, rethreading right the way round
the necklace (so doubling its strength). Tie the ends securely.

8 Attach a calotte around the seed bead at each end of the string.

9 Attach a bolt ring and eye to finish the fastening.

Fizzy Apple Jellyfish

Changing the colour of this necklace from cherry red and silver to green and gold gives this design a more mature, natural organic look.

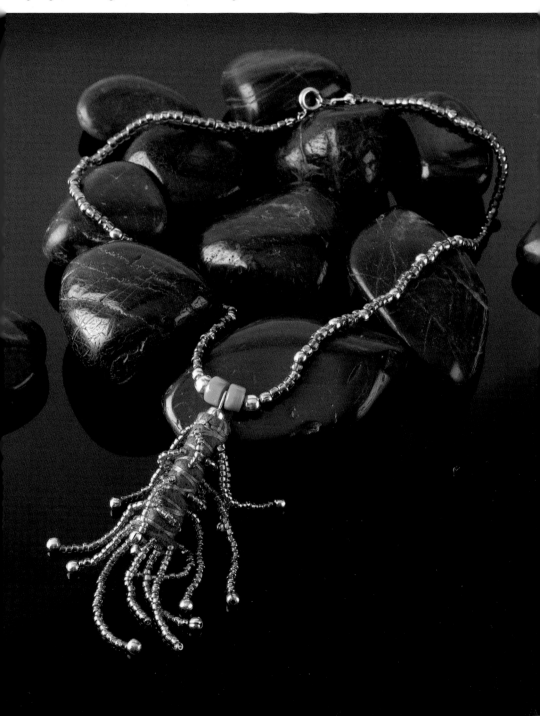

Sparkling Sherbet Drops

Materials:

2 x black felt pieces, 2 x 3cm (¾ x 1¼in)
8 x medium silver beads
4 x small silver beads
4 x headpins
2 x eyepins
2 x long ball wire earring hooks
Selection of silver seed beads
Black embroidery thread
Beading thread

Tools:

Round-nose pliers
Flat-nose pliers
Cutting pliers
Scissors
Beading needle
Needle

Instructions:

1 Bind the felt pieces into two beads using embroidery thread and attach seed beads, following method E.

2 Thread one medium silver bead, the felt bead and another medium silver bead on to an eyepin.

3 Snip the eyepin to length and create a loop. You need to leave about 1cm (½in) of the eyepin above the beading to form the loop.

4 Attach an earring hook to one end of the eyepin.

5 Thread one seed bead, one medium silver bead and one small bead on to a headpin. Snip the headpin to length, and create a loop.

6 Repeat step 5 above, but add three more seed beads before snipping to length.

7 Attach both headpins to the eyepin.

8 Repeat for the second earring.

Sparkling Orange Drops

You can make earrings to match any of the necklaces shown in this book. Here I have used the beads from the Rhubarb and Custard design (page 15). The only limiting factor is your imagination!

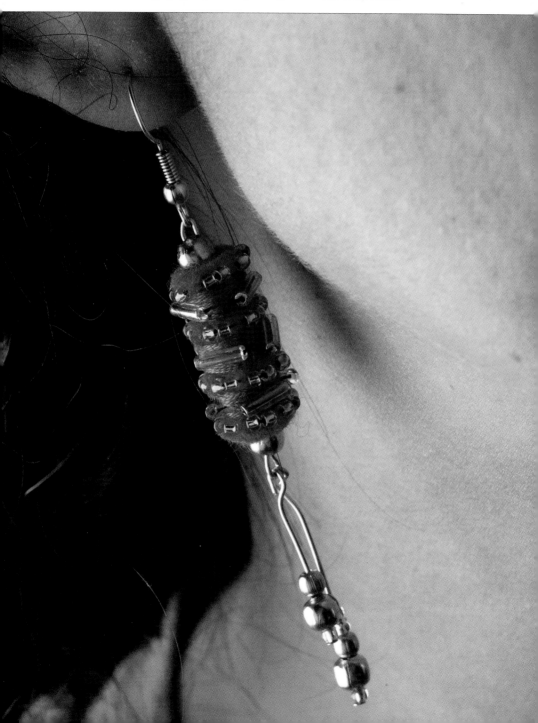

Acknowledgements

Thank you to Roz, Katie and all the team
at Search Press who have made the
publication of this, my first book, such an
enjoyable experience. Thanks also to Laura
Chester and Laura Hayward who modelled
my jewellery so beautifully. Lastly, thank you
to my sister, Lizzy, whose love and support
helped me to believe that everything and
anything is possible.

Publishers' Note

If you would like more books on jewellery
making, try the following
Search Press books:
Simple Button Jewellery by Karine Michel
and Katia Richetin, 2006
Necklaces, Bracelets, Brooches and
Rings using Crystal Beads and Crystal
Beaded Jewellery by Christine and
Sylvie Hooghe, 2006
Dare to Bead by Heather Laithwaite, 2006
Designs for Beaded Jewellery Using Natural
Materials and Designs for Beaded Jewellery
Using Glass Beads by Maria Di Spirito, 2006
100 Beaded Jewellery Designs by
Stephanie Burnham, 2006
The Encyclopedia of Beading Techniques by
Sara Withers and Stephanie Burnham, 2005